ALEX SIMM

THE ART OF MAKING COMICS

WRITE DRAW PUBLISH

A Step-by Step Guide to Bringing Your Comics To Life

Published by
SKYHIGH BOOKS
a division of Simmons & Co. 2016

Text copyright© 2016 by Alex Simmons
ISBN: 978-1539828235

Book cover and interior design by
Elizabeth Sheehan Graphic Design

Greetings!

My name is Alex Simmons, and I am a *freelance writer*.

Now for those of you who don't know what freelance writer means ... trust me, it doesn't mean that I work for *free*. Au contraire!

It means I can work for any company or client who will pay for my particular skills. And over the years I've worked for as many different clients as I could.

I've written plays, song lyrics, magazine articles, video and radio plays, children's books, and last but not least, comic books and comic strips.

For years I've played wordsmith, writing stories about Sherlock Holmes, Batman, Tarzan, Scooby Doo, and Archie, just to name a few. And of course there were my own creations, the Demon Chronicles, Sci-Tech Heroes, and my award-winning comic book series, BLACKJACK.

While growing up I watched a lot of familiar characters on television and read about them in comics. I saw Tarzan in the movies, and one time I masqueraded as The Shadow on Halloween. My friends and I even dressed up as comic book characters and made our own home movie adventures.

To do all that as a child, and then grow up and be able to actually write real stories for these characters is about the coolest thing ever.

It's amazing how far a person's imagination can take them. ***Never forget that***.

Imagination is the greatest superpower of them all.

But you didn't come here to listen to me go on about my youth. You want to know how we do it. How do we create comic books and comic strips, cartoons, and more?

So let's get to it!

Contents

Who Does It?

Whether you're creating comics for yourself, family, friends, or the buying public, there are six key jobs to fill. That's right, six!

Now in some cases one or two people might do them all, but most of the time, in the business of making comics, six different people must be that good.

To start, we need a story.

I know many of you figure the illustrator does it all, but if that were true, I wouldn't be here typing away on this book.

Nope. To obtain a story 90% of the time, we go to ...

❶ The Writer

The WRITER'S job is to come with the story, even if he or she didn't create the lead characters, or someone else came up with the idea for the story. The Writer still has to put it all together.

Let me repeat, IMAGINATION is key.

Let's say you are the Writer. Even though you may be working on a story with someone else's characters you will still have to create new *supporting* characters.

When I write for Archie Comics, certainly my stories contain some of their main characters (Betty, Veronica, Jughead, and Archie). I even sometimes use several of their supporting characters (Mr. Weatherbee, Dilton, Hot Dog, etc.). But most of the time I have to come up with someone new. And sometimes I have to create a new location, inside or outside of Riverdale.

When I wrote *Batman: Orpheus Rising*, I created the new character called Orpheus, plus his whole family, friends and en-

emies. But I still used Batman, Robin, Batgirl, and a host of other *Bat Folks* (that would make an interesting title for a new series).

This means that having an active, free-flowing imagination is useful ... Heck, it's downright necessary!

So, once the Writer creates and hands in the Script, it is reviewed (by someone we'll talk about later) and handed off to the next artist in line ...

❷ The Penciler

Sounds a bit like someone who rode into town looking for the Marshall. Beware The Penciler!

The Penciler has the challenging job of drawing the whole story in pencil ONLY.

Yes, in the wild, wild, world of independent comic book creation, some people have more than one job. But for the sake of this chapter I want you to know the individual job titles and responsibilities first.

The Penciler receives the script, does breakdowns of all the pages, illustrates them, and then sends them back to be reviewed.

Sometimes the Penciler will draw exactly what is in the script, panel for panel. But often they might envision a better way to illustrate a scene or sequence of action. After all, they are the visual artists, and rendering great visual art is their job.

Thumbnail pencil sketch

So the pages come back into the "office," and they are reviewed by the Mystery Job Person, and then sent off to another talent in the lineup.

To meet that person let's use my amazing Time Machine For A Moment ...

Alex Simmons

Back in the days before computers, the pencil art would go to ...

③ *The Letterer*

We're back... in the day with the Letterer. This is the person who takes the original penciled artwork and writes on it (by hand), all the words you read in a comic book. That's right — everything that is said or thought by the characters, or stated in the caption boxes.

What's a Caption Box? We'll get to that later.

Even during our wild years you tried to make things right ... Most of the time anyway.

Okay, now you're The Letterer. You also work in pencil. You're drawing each word in capital letters, unless you're going for a special effect, like making it look as if someone wrote it in script, or some ancient language.

You have to be careful not to smudge the artwork, and you have to hope that the Penciler left enough room in each panel for the amount of words needed.

Moving on. You finished lettering the whole story and send it back to HQ, where That Mystery Person reviews the work and sends it off to next person...

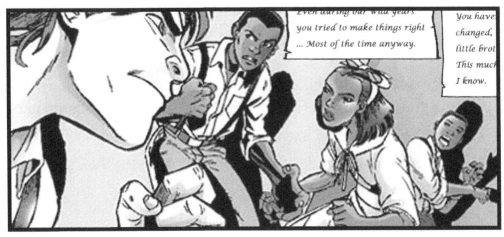

Steve Ellis

❹ The Inker

Back in the day, the Inker would receive the pages, pick up their inking pens or brushes, and go to work. Being as careful as possible, the Inker would go over every single line the Penciler drew.

Also, the Inker would fill in (with black ink) every shaded area that was supposed to be solid black. Then the Inker would go over every word that the Letterer had written on the page.

That was a LOT of work for one person. They had to be super-careful, because if they made a mistake and couldn't fix it, they were exiled to — No, not really ...

Well, not all the time.

No, the problem was that if they couldn't fix the mistakes, the art had to be redrawn by the Penciler. That cost extra time and money.

1940
1960
1980
2000
2016

Losing time and money usually make someone unhappy. Might even be you.

But that was then.

Now before we go on, let's hop back in the time machine and return to the present. Nowadays, with computers taking over ... Uh, I mean making things more efficient, there are different ways to create a comic. Here are three:

Method #1: Tech

- The Penciler's art is inked and then scanned into a computer.
- The scanned art is sent to the Letterer (as a digital file).
- The lettering is added on a computer, then the file is sent back to production.

Method #2: Tech

- The Penciler's art is scanned into a computer.
- Then the original art is sent to the Inker.
- When the inking is finished, it is scanned and sent back to production.
- Meanwhile, the scanned pencil art is sent to the Letterer.
- The Letterer's work is sent back to production, where the files are blended.

Method #3: No Tech

- The Penciler's art is sent to the Letterer.
- The Letterer's finished work is sent to the Inker.
- The Inker inks everything and then sends it back to production.
- Production makes copies of the black-and-white pages and sends that to the colorist.
- The Colorist (we'll talk about this person in a moment) colors the copy, creating a Color Guide for production.
- The black-and-white art is scanned into a computer where the coloring is done based on the Color Guide.
- The book goes to the printer from there.

Freehand inked version

Alex Simmons

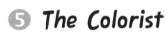

⑤ *The Colorist*

Let's explore the Colorist's job a bit.

If we were to jump back in the time machine *again* (which we won't because I just ate lunch), the Colorist would get photocopies of the inked pages and use very EXPENSIVE markers to color in all the art. The finished product would be called a Color Guide.

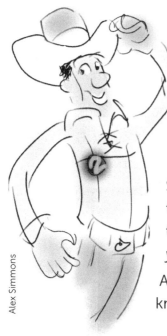

Final color version of character

Alex Simmons

But since we're still here in the 21st Century, the Colorist receives a digital file copy of the inked pages. Then, using any one of several popular computer coloring software packages (i.e., Photoshop, *Manga Studio, etc.) they color the work and send it back to the "Big Cheese." Well, not *that* big cheese, but that mystery person (*whom we haven't named yet)* who has to look over everything.

And who is that mystery person? Oh I *know* you know.

⑥ It's *The Editor*

The Editor is the one person who has to review everyone's work. Personally, I feel the editor's job is one of the toughest in the business. This person has to ...

- Check the script for clarity, as well as story and spelling errors
- Check the artwork for mistakes and clarity of storytelling, i.e., did it follow the script properly? If the artist changed anything, is it for the better?
- Check the lettering for spelling errors and the proper placement of words on the page.
- Check the coloring to make sure it's accurate, as well setting the right tone or mood for the story. For instance, it wouldn't do for a night scene to be colored with bright blue skies and sunny lighting.

The Editor also has to make sure that the books are *on time,* well executed, and thoroughly enjoyable.

Showing you how to accomplish that is what this book is all about.

Terminology

Talk That Talk

Okay, in order to think like a comic book creator, you have to know how to speak the language. We have certain terminologies, words we use to express what we're doing from one moment to the next. (*See full definitions in Glossary*) **Some of the basics:**

Panels

Caption Boxes

Characters

Speech Balloons

Thought Bubbles

Splash Page

Double-page Spread

POV

Thumbnail Sketches

Layouts

Sequential 1 2 3 4 5 6

Comic Books

Comic Strips (Dailies and Sundays)

These are just some of the phrases we use to express the different parts of the work we do. Memorize them. They'll be a pop quiz later.

Just like mainstream publishing (aka non-comic books), there are different genres (categories) in comics. Although I have to say, not as many as in the past... but I am hopeful for the future, thanks to many of the independent books being produced.

So, think outside the superhero box when you think comics.

Comic Books Categories:

Superheroes	**Action/Adventure**
Humor	**Supernatural**
Mystery	**Memoirs**
Westerns	**Romance**
History	**Children's**
Manga	**Crime**
Drama	**Auto-biographical**
Science Fiction	**All Audiences**
Biographical	**Anthropomorphic**
Mature	**Martial Arts**

All right, now you're armed with a basic understanding of the jobs and their responsibilities, certain terminologies, and some of the book genres. Time to start the creative process. And in this book we start with ...

What a Character!

There's an old writer's creed that goes,

"Plot is character, and character is plot."

That applies in all forms of storytelling, and comics are no exception.

Some writers like to start with a good *plot*, and some with an **inspired** character. Either way, good characters are integral to any story.

Even if you're working on characters created by someone else, you need to know as much about them as possible.

So, that's where we'll start.

As I said earlier, Imagination is a superpower. It is the source of everything we're about to accomplish in this book, and beyond.

Your character will start right there.

Perhaps it will come to you because of something you once read, or saw, or heard.

I don't mean you flat out copy the idea. I mean something about that source sticks in your mind and causes you to think about it from a different angle..

Or maybe it comes out of a dream you once had, or a nightmare (*not fun, but useful*). Sometimes an idea for a character is sparked by a piece of music, an image, or truly yucky food.

Whatever the spark, you take it and throw it into a place I call *What-If City*. It's a place in my mind where I take an idea and ask, what if ... ?

Alex Simmons

- Norse gods really came to earth? What form would they take?
- What if mankind really begins colonizing outer space, what would happen? What would the first aliens we meet look like and be like?
- What if the best spy in the world was a teenager haunted by childhood nightmares?

I ask these questions, and then eagerly, or cautiously move through a sea of possibilities. The thoughts and images come to me, and I begin to create my own thing.

Sure, creating characters can be difficult, but it can also be crazy fun and exciting. Remember, you have total control in your imaginary world. This is your playground, so go **PLAY!**

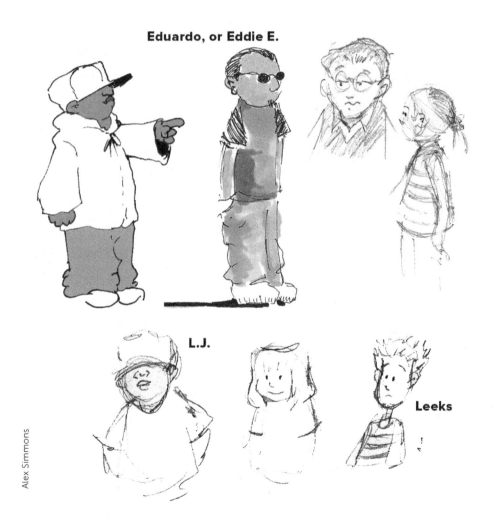

Eduardo, or Eddie E.

L.J.

Leeks

Alex Simmons

Putting Pencil to Paper

If you like to draw, you might start by sketching it out first — simple doodles to help you decide what your character looks like.

Or you might be more comfortable writing down your ideas. You record the Character's looks, personality, origin, goals, and so on.

In a moment, I'll share a list of some questions you might need to answer as you create your character.

Note I said *character*, not *he* or *she*. I used this word because a character can be **anything!**

It can even be an inanimate object, as long as you give it life and personality.

See, you're at the point of creating someone or something that did not exist before. So you might come up with a man, woman, animal, or an entirely new race, culture, or species.

> **A Character Can Be:**
> (Short List)
> - Human
> - Animal
> - Robot
> - Ghost
> - Alien
> - Plants

Or you might take a look around the room and be inspired to give life to inanimate objects. The stars of the animated film, THE BRAVE LITTLE TOASTER, were a rug, lamp, vacuum cleaner, and of course a toaster. The Disney movie, BEAUTY AND THE BEAST was chock full of talking furniture as well as dishes and other household items.

Exercise: look around the room and pick 3 things and make characters out of them. Give them a name, face, and personality.

That's the cool thing about being an artist on paper or in the digital world — you can create most anything, You are not bound by most laws of physics.

Stop and think for a second. Who are some of your favorite characters in fiction, and what are they? What makes them fun or interesting to you?

Pretty cool, yes? Now here is that list of questions I promised. They will help you to create your own character's personal look, life and history.

Character Bio

What you need to know

When we create a character some of us keep all that information in our heads. And depending on the size of our noggins (heads, brains, etc.), that could get a little cluttered.

So, in the business of comics it's a good idea to create what we call, **CHARACTER BIOS** (biographies). It's a list of character information that can be a gold mine to an artist (*by the way, WRITERS ARE ARTISTS, too*).

A Character Bio allows you to list (or brain dump) everything you can think of about your character into one place. And the more you know about them, the easier it is to write your story.

Make a list of some sample questions you should ask yourself

SAMPLE QUESTIONS

- Name

- Age

- Gender

- Species

- Where is it from?

- What does it want? *(Goals, aim, ambitions)*

- Who are its friends and enemies?

- Does it have family?

- What are its abilities

- What does it look like? *(Height, weight, color of eyes, hair, skin, etc.)*

- What are its favorite foods

- Does it have a job?

- Schooling

- Favorite clothing

- Does it like or play sports

- Is the character very smart, or of average intelligence?

- Does the character have a small ego, or a big ego, or no ego at all?

- Is the character shy or out going?

- What are some of the fun things the character enjoys?

- What are some of the scary things the character fears?

- Does it fear only one thing?

And there's always the **Situation** (*what's going on in the character's life?*) You should put a lot of thought into this one.

Example: If the character is 15 years old, and lives alone in the forest ...

- Why?

- How did that happen?

- How does the character feel about it — Happy? Sad? Doesn't care or know any better?

Sometimes answering questions like this can become your first story, or at least the beginning of it.

Modeling Your Character

Another piece of advice is when in doubt, *"Write what you know,"* at least to start.

Artists pull from life all the time, even when they're creating stories about a fantastic world.

Superman is an alien from another planet. His creators Joe Shuster and Jerry Siegel were boys whose families had come from another country ... another world. One term we use for people like that is, "aliens."

Superman's parents raised him to be a good man and a good American citizen, just as Joe and Jerry's families tried to be. I've no doubt their life experiences played some part in the boys' creation of that iconic character from another world.

To give Marvel fair time, the **X-Men** are a grand example of society's outcast community. Whether it's because of your size, looks, social standing, race, or culture, many of us have felt like outcast at one time or another. So, many people can relate to these characters.

Pulling From Literature

Books, as well as real life often inspire writers.

The **Hulk** and his plight can be compared to the fictional character Dr. Jekyll and Mr. Hyde, or Frankenstein. Which raises the question where did Mary Shelley get her inspiration? For sure, grave robbers were prevalent in her day, so that could have been one source for story development. But what else influenced the telling of that tale?

Have you ever read anything on Greek mythology? Pretty wild, right?

Who wears a helmet on his head and can run with the speed of light?

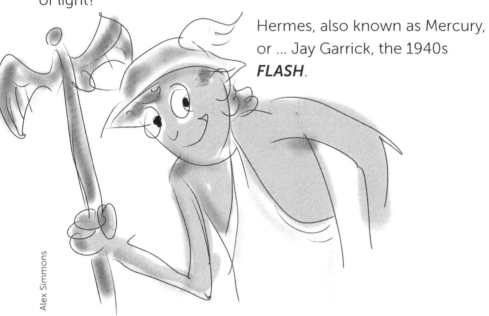

Alex Simmons

Hermes, also known as Mercury, or ... Jay Garrick, the 1940s *FLASH*.

Artists are influenced by what they've been exposed to in life, so look around you. Take it all in.

Sherlock Holmes told Watson, *"You see, but you do not observe..."*

That meant that Watson did not really notice details. He would see a person, but not notice a stain on their clothing, or the color

of the mud on their shoes. For years, Watson mounted the stairs at their Baker Street lodgings without ever noticing how many steps he climbed. Of course Holmes saw it all..

Ilan Fleming, the man who created and wrote the James Bond books, had been an actual spy for British Intelligence. He admitted he didn't get the girls, and not all of his missions went well. But he called on his real-life knowledge and experience to create the super-spy we know so well.

Notice how people talk, how they act, and what they wear. Notice animal and insect behavior too. The creatures in the movie "**Alien**" seemed to live only to kill and reproduce. (*I imagine they ate, but I really don't want to think about that too long.*)

There are animals and insect on our planet that live very similar life styles. (*Makes science classes a little more interesting, huh?*)

So many things can be a source for character ideas.

A Hero Please

With or Without Mayo?

What is your idea of a Hero or a Villain?

That may be an easy question for some of you. Not so for others.

Back in the day, Heroes were easy to spot. They wore certain clothing, did certain heroic deeds, made major sacrifices for others, and asked for nothing in return.

Villains ... did the opposite..

That was the past.

The rise of the anti-hero

Over the few years comic books, movies and more have embraced the idea of the **Anti-hero**. They've chosen to show more of the gray areas of life. In other words, not everything is one thing or the other.

The Anti-hero is not quite a good guy, but does something good for his own reasons, or by accident, or necessity.

In the original **Star Wars** series, Han Solo was not a true Hero at first. He was more of a con artist, a flim-flam man who made "shaky deals" with dangerous characters, in order to make money. It isn't until he gets caught up in the adventure with **Luke Skywalker** and **Princess Leia** that his motives change and he winds up doing the right thing for the right reasons ... in his own way of course. He in fact becomes a reluctant Hero, a friend, and more.

As the artist, you get to decide what your character is like and their **motivation** (why they do what they do). And once again, the more you know about your character's history, needs, goals and feelings, the better the story you tell.

Having said all of that — let's talk about story. In particular let's talk story ideas, aka...

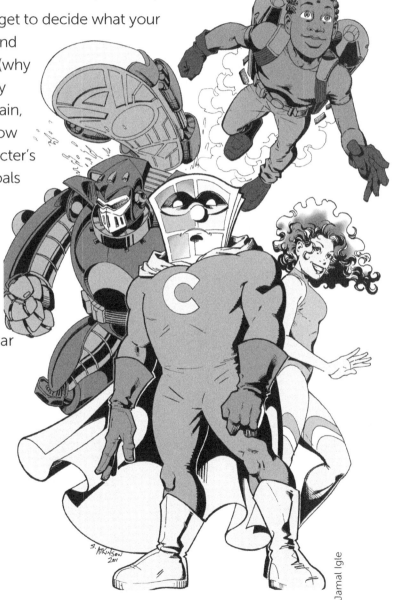

Jamal Igle

Create Your Own Character
or Character Bio Here

The Plot Thickens

Simply put, the **plot** is the basic idea of the story.

You may have a rough idea of how your story starts. You may know what it's about and maybe have a nice ending in mind. But you do not necessarily have any of the details worked out.

That's fine. That can develop in the **outline** and **scripting** phases.

At this time, it is just important that you write down your *basic* idea for the story.

Twenty writers can take the same writing course from the same teacher at the same time, and once out on their own, they'll find out what works and doesn't work for them. They develop their own style and methods, keeping only some of what their teachers taught them.

So, whatever I say is not the sacred rule for all. But it works well, until you find some other method you like better.

Having said that, I find that sometimes I'll have an idea for a story, but until I start seeing the characters clearly, the idea stalls.

Other times, I'll come up with a character, and a plot will come to me almost instantly. What I've learned is that, for me, my method proves the quote I mentioned earlier: "Character is plot, and plot is character."

Some stories are completely plot-driven, and the characters act pretty much like so many puppets jerked about by a puppeteer being attacked by bees.

A good plot with a good character works so well, it looks as if we're peeking into the character's life at a crucial time.

So, if you have a great character already, start to think ...

- What do I know about this character?
- What does it want?
- Where is it from and where is it going?
- Who does it know, love, or fear?

Yes, you go back to your Character Biography and look at those questions and answers, and maybe come up with a lot more.

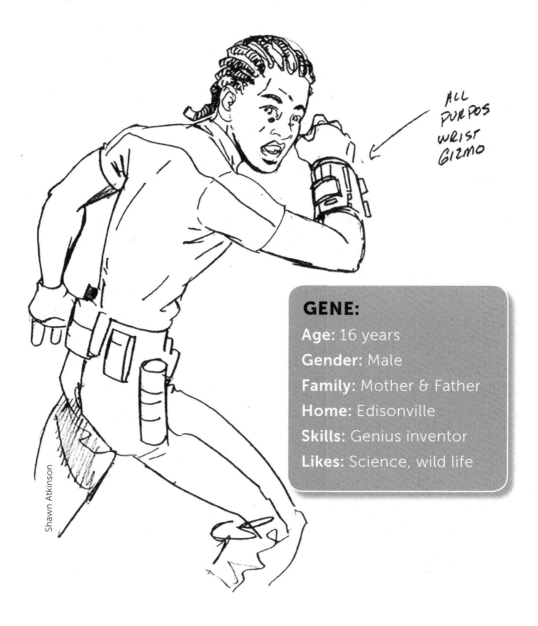

ALL PURPOS WRIST GIZMO

Shawn Atkinson

GENE:

Age: 16 years
Gender: Male
Family: Mother & Father
Home: Edisonville
Skills: Genius inventor
Likes: Science, wild life

Plotting Work for Hire

When I create stories for a series that already exists, or belongs to another person or company, I do my homework, first. I ask ...

What do I know about the characters already (*sound familiar*)?

What kind of stories have they already done?

Can I use any of that material?

Do they want me to?

Then there are the really fun questions that tumble out ...

*What do I really **want** to do here? How many pages do I have? What kind of story do I want to tell?*

When writing for yourself, you have much more freedom. The first four questions usually do not apply. But the last one certainly becomes a key part of your thinking.

Other questions you might ask ...

1. What is your story about basically? What is the theme or moral?

2. Who and what are your characters?

3. How does your story begin and end?

4. Where does it take place?

5. Where in time does it take place? That's right, eras matter.

6. What do you want your characters to learn from the story?

7. What do you want your audience to feel or learn from your story? That last question was one of the big ones for me when I wrote the graphic novel, *Blackjack: Blood & Honor.*

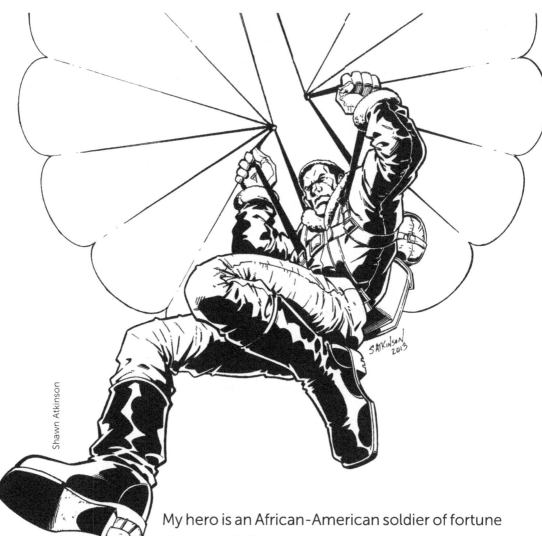

Shawn Atkinson

My hero is an African-American soldier of fortune who had followed in his father's footsteps. In fact, he admires his father greatly and wants to be like him. But he also realizes that he's different from his father in certain ways. Seeking answers, he takes on an assignment to bodyguard a certain man, someone he knows his father might have turned down due to his own prejudices. So my hero wants to know if he has the same prejudices, and if so, will he do the job and do it right?

My hero is on a *quest* to find the enemies of his client, but also the enemies within himself. Simply put, will he do the right thing?

This is a good example of a plot driven by the character's needs or goals.

In the basic comic book stories of old, the Villain planned a crime, which the Hero tried to stop. The Hero would get into trouble but somehow overcome it and stop the Villain in his tracks.

Sometimes the Villain would pull off the crime, and the Hero would have to catch him.

In this type of story, you simply decide which will be the most thrilling, or fun, or exciting, depending on what kind of story you want to tell.

Example:

An earth ship lands on a distant planet. The crew goes to explore the planet and is attacked by a vicious creature. By the end of the story, the surviving crewmember(s) escape.

That's your basic plot. This would make a good One-Shot, a story that can be concluded in one issue.

Then you ask...

- How many crewmembers?
- What kind of creature, and what does it do to its victims?
- Where is this planet?
- Why is the ship there?
- How do the survivors deal with the creature?
- Do they succeed in killing it, or simply escape it?
- How do they escape, and how many really survive?
- These are good basic questions. Once you answer them, you have a good idea of how your outline and script will flow.

The trick is to keep the story simple, but answer all the necessary questions to leave your audience satisfied.

If you wanted to make a more **complex story**, the plot might look like this ...

SAMPLE EXERCISE

An earth ship lands on a planet on the outskirts of known territory. The crew has been told it is merely an exploration mission, but two additional members may have a different agenda.

Once on the planet a vicious creature attacks the crew. As the body count mounts and supplies dwindle the Earthlings discover a secret they may have to die to keep. By the end of the story, the surviving crewmember(s) escape ... *maybe*.

Now you might ask the following:

- How many crewmembers?
- How do they get along? Are there any rivalries, conflicts, or secrets between them?
- What kind of creature is it?
- What does it want or need?
- Does it think, or is it acting on instinct?
- What does it do to its victims?
- Why did the ship come here?
- Is it a peace mission, an explorer, or out for some sort of other gain?
- Where is this planet?
- How do the survivors deal with the creature?
- In dealing with the creature, do any of the crewmen sacrifice another or sacrifice themselves?
- Do they succeed in killing it, or simply escape it?
- How do they escape, and how many really survive?
- Do they truly escape, or is there something they don't know?

The more you develop the plot and the characters the bigger the story, and probably the more time/pages it will take.

Let's look at two plot examples from a couple of my early assignments, but first a word about formats.

A Plot Synopsis Contains:

A Your name and the date

B **TITLE OF SERIES** (*If this is a series*)

C **TITLE OF STORY**

D Describe how story begins.

- Characters: Who are they?

- Location: Where does it take place?

- Time period: Day, night. Year if needed.

E Describe in a few words what happens during the story.

- What happens to the characters? Mention the most important and exciting parts ONLY.

F Describe the ending.

- How does it end?

- Who wins?

- Who loses?

- What changes?

Example:

Below is the plot for a **Scooby-Doo** story I wrote for the DC comic book series. See how it lines up with the outline above.

A Alex Simmons / Date

B Scooby-Doo Series

C "DEAD AND LET SPY"

D Even a top-notch secret agent needs help when the enemy agents are zombies! America's best teen secret agent, **JZ BANG,** can't come in from the cold (with vital information) because a supernatural army is after him.

E So Uncle Sam (Literally. His bureau chief is his uncle, Samuel Bang) calls in Mystery Inc. to get JZ from foreign to friendlier soil ... alive! It's all gadget and ghouls in this 00-Scooby globe-trotting adventure.

F In the end, the villain turns out to be an intelligence-gathering evil genius named Cadaver. He earned his nom de plume because he likes to use supernatural illusions and such to unsettle his quarry. And it almost worked, as young JZ never got over his childhood Boogeyman fears. Nevertheless, the Scooby gang and JZ make it home, beat the bad guys, and deliver the secret information — in the nick of time.

More Detailed Plot:

ARCHIE miniseries, **"Archie's World Tour."**

BOOK ONE

TINKER, TAILOR, STUDENT SPY

The original plan was to take the class on an educational, five-country trip to experience cultural and global awareness. While Betty and Veronica were looking forward to meeting some cute guys, Archie and Reggie were planning on admiring their own form of *continental* curves, and Jughead was eager to do some global smörgåsbord gorging.

The trip would take the gang and their classmates from London to Spain, to Nairobi, and then on to Greece, and finally Zurich, Switzerland, all in the name of education — and fun.

When the gang arrives in London, they take a group picture *(which will later help Archie discover the final clue in the case)* before entering their hotel. But as they move across the lobby, a nervous woman crashes into them, creating quite a jumble of hands, legs, and luggage. The woman is a spy who secretly hides something on them, then races out the front door, where she is grabbed by men and thrust into a waiting cab.

From then on, while touring London and later Spain, reluctantly gaining some culture, the gang becomes the target of some

nefarious characters. Bad guys chase the boys while their suave cohorts try wooing Veronica and Betty. After a healthy dose of humor and dastardly dilemmas, the kids assume they are the targets of common thieves. And when they finally capture the thugs, Archie and his classmates naively believe it's all clear sailing from here on.

But as the first story ends, a cliff-hanger ending reveals to the reader that the adventure is far from over as shady characters follow our gang onto a plane for their **Nighty-Night Flight to Naorobi.**

Now let's see what you can do.

Exercise: Create 2 different plots. Make one simple and the other more complex. And here's a worksheet to help you...

Work Sheet:

A Your name and the date:

B TITLE OF SERIES (*If this is a series*):

C TITLE OF STORY:

D Describe how story begins.

- Characters: Who are they?
- Location: Where does it take place?
- Time period: Day, night. Year if needed.

E Describe in a few words, what happens during the story. What happens to the characters? Mention the most important and exciting parts ONLY. DO NOT tell the ending yet.

F Describe the ending.

- How does it end?
- Who wins?
- Who loses?
- What changes?

27

Creating An Outline:

Let me put in a quick word about creating an **OUTLINE.**

An outline is like a road map that gets you from **start** to **finish**, and it points out places you **have to see** or visit along the way.

There are different ways to write one. Some have a lot of detail and some have very little. I suggest you start out writing it like a grocery list. Keep it simple at first. You can always go back and add details. And you may not figure out some of the details until you are actually writing the story.

In comic book, **Start** would be Page One. As you go along the trip you decide what must happen, and what we must see, on each page until you reach the end.

In a comic strip, it would be Panel One, then Two, and so on. It's still where does your story, or joke, begin and where is it going?

For a 22 page comic book that writer would outline the whole story, first. Writers need to know where they are going and how to get there. The outline helps. (*See example at right*)

After outlining the whole story, the writer then has to plan what happens on each page and in each panel. Sometimes you can figure this out by doing little thumbnail sketches with your outline.

Alex Simmons

28

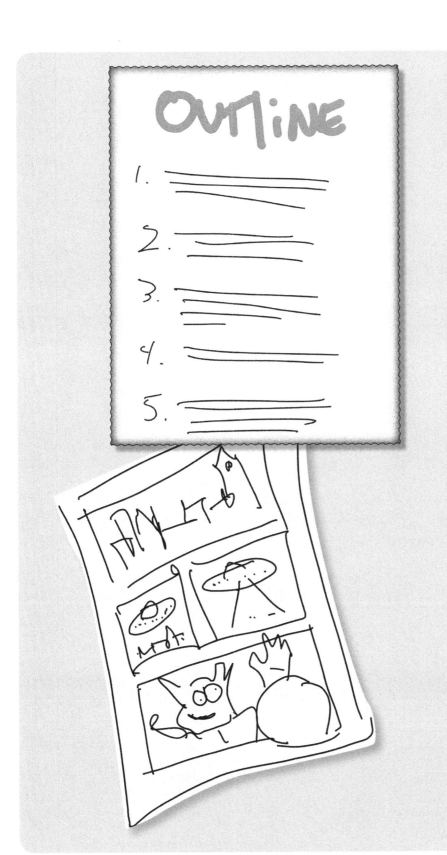

Create Your Own Plot
or Outline Here

5 The Script

Now that you have some idea of how to create plots and outlines, let's start working on writing a full tale in scripted form.

But first, let me get two nasty words out in the open right now.

EDITING & REVISIONS

There, I've said them right up front, so you won't be shocked when they come up all through this chapter.

Edit! Revise! "You mean I have to read through my whole story and fix stuff?"

Actually ... **No**.

You don't **have** to. If you don't care if things are misspelled, unclear, missing, or incorrect, you can walk away from your story the second you finish it.

In fact, you don't even need to be reading this book. Go write something, draw some pictures, and print the whole thing out. Sell it to some people and see what happens.

But ... if you **care** about making your stories the best they can be, for you and your audience — then **yes**. Editing and revising your scripts is all a part of the adventure.

Okay? Then let's get started.

There are so many ways to approach writing a script. First, there's the method taught in a school, or in a course online. It's a formulaic structure that many writers adhere to, or utilize well.

Then there's the free-flow from the heart and mind method. It will certainly create equally stirring tales, possibly with a few structural concerns, but they can be addressed later.

The bottom line is that every writer has his, or her, own style of writing. Some comic book writers have very little description for each panel. This leaves 90% of all the visual decisions up to the illustrator.

Other writers' descriptions are so detailed that they almost double the length of the average comic book script. This is not necessarily a bad thing. Their attention to detail is often for very solid reasons.

My style falls somewhere in between.

If I have a strong vision of what a particular panel or scene should be, I will describe it as clearly as I can. This is especially necessary when writing mysteries or suspense stories.

EXAMPLE: Page three

PANEL ONE

Action: As the detectives and their client pile into the Rolls, and a second car, we see past them to a truck across from the station. A man in workman's clothing is leaning against it.

Benton: (Calling out to men getting into second car) Straight to the Count's mansion. No stops.

PANEL TWO

Action: Arron has spotted the truck as the man hurries to the back of it. Simultaneously, a messenger on a motorcycle is pulling up near Arron.

Caption: Funny how some men see what they want to see ...

PANEL THREE

Action: As the man leaps into the back, Arron can see 5 other men, with guns.

Caption: And miss everything else. Especially the ones like Benton ...

[*Excerpt from, "Blackjack: There Came A Dark Hunter," © Alex Simmons]

But I'll try not to use a thousand words where a hundred will do.

You may have a specific idea of how the visuals need to unfold. There may be a clue or image that must be presented in a certain way, or in a particular order.

So writing the details can be overdone at times, but they also can be helpful and necessary.

Keep in mind that a comic book, like a film, is a **visual** medium. This means the pictures are just as important as the story and the words — in some cases even more so.

PAGE ONE

Panel 1

Full PAGE Spread. We are in the hallway of a palace in Tibet.
ARRON DAY, aka BLACKJACK is crouched in a defensive posture, one gun at the ready, as his other hand takes the pulse of a man by his feet. This man is Asian, but dressed like a westerner (like Arron). The man has been shot several times and is dead. There are numerous other bodies around them. Two others are dressed in that a-typical safari costume we're so familiar with. One man is white the other Asian. There are also a few Tibetan soldier scattered around. This is a battle zone, and it looks like its heavy casualties on both sides.

I should mention that the only other person standing near Arron is HENRI. He has a rifle (of the era) in his hands, a pistol holstered on his hip. He wears his "lucky" French Foreign Legion jacket completely opened at the front. No hat. Henri is just as alert and tense as Arron. He is looking in the exact opposite direction Arron is, covering what his friend and partner in war is not.

[* *Jamal, this scene is somewhat reminiscent of the shot of Matthew Day and Silas Lincoln in that first issue of BLACKJACK: Second Bite of the Cobra. Not exactly, but it should stir thoughts for anyone who has followed the series.*]

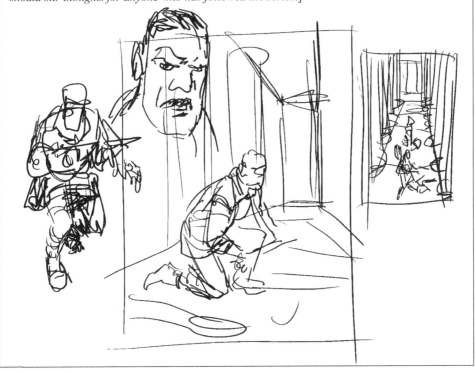

How To Start

If you have worked out your PLOT and your OUTLINE, then you have a good idea of how your story should flow from beginning to end.

You also have a good idea of what happens on each page and in each scene. Writing the script is laying out everything in proper order, and with the proper amount of details.

For those of you who have trouble deciding how things should look visually, I always make this suggestion:

What is the first thing we see on the screen?

Think of your story as a movie. See the screen blank or dark at first and then imagine how the movie starts.

Once you see that image, roll the film forward in your mind.

What happens next?

When do the characters appear?

Where are they? What are they doing?

Work this way scene by scene.

Once you've written out each scene, in their proper order, panel-by-panel, you're ready to go back and review your work. Your goal is to improve the dialog, narration, and/or the action.

There are three main components to a story ... the Beginning, the Middle, and the End.

The **BEGINNING** sets things up. Where are we, what characters are being introduced, and what is happening to them.

By the time we reach the **MIDDLE**, we should know who the characters are, especially the leads, or main characters.

We should also know what conflict or challenge they're up against.

And most important, by this point **we should care** about the characters.

If you don't care about your lead characters, whether they're Heroes or Villains, it will show in the storytelling.

If your audience is not into the characters by now, then they won't be caught up in the rest of the story.

So by the Middle we should know the CONFLICT, and most

of the CHARACTERS. We certainly should know your lead characters and hopefully care about them ("we" being the artist and later the audience).

Now let's talk about the **END**.

This is crucial in several ways. Obviously after the middle of the story, we reach the **climax.** Whatever the challenge the story presented, it comes to a head, whether in an emotional situation, a comedic punch line, or a battle royal between good and evil.

After the climax comes what we call the RESOLUTION. This means the story has come to an end and we are winding down, we're sending the Heroes or Villains on their way.

You want to hook your audience from the beginning, so you must give them an interesting, or moving, or exciting opening scene. To do that, we must make the characters as interesting as possible. We must move them along, developing their story so the audience cares what happens to them. They can care out of genuine sympathy, or out of genuine interest and curiosity. But they need to be engaged, caught up in the tale.

So you have to envision the story in your mind like a movie. See it [] unfold, step by step. Then write them down and follow through from beginning to end until you have your first **ROUGH** draft.

35

That's right, only the **ROUGH** draft. Now do 3 things ...

1. Read through it and correct any mistakes you see.

2. Put it away and go play, nap, or chase porcupines barehanded. Ouch! Basically, I want you to take some time away from it.

3. Go through it again and make any improvement you want.

Now you have a **FIRST** draft. This is how we review the work and decide, with or without an editor, whether or not we reached our goal.

Once the first draft is finished, I suggest you put it away for a day or two and then come back to read through it with what we consider *fresh eyes*.

Fresh eyes allow us to be *introduced* to our own story almost as if we haven't seen it before. We more clearly spot what connects, what works, and what doesn't. Then it's on us to improve the draft, go through it, make the corrections, and then put it away again. This time, maybe only a few hours or one day. And after that, pass through it one more time to see if anything else stands out or need additional work — period.

You may not have to go through a comic strip script this many times because it is a shorter format, and you are often telling a 3 or 4 panel joke.

But many people do create very detailed scripts for their comic strips, especially if they are telling an ongoing comic strip story.

The whole purpose of revisions or editing your story should not be seen as, "**Why me?** I have to look at this **again**?"

Instead it should be looked on as a blessing, an opportunity to make this story the best you can the first time out.

One way or the other, the work should go before the eyes of an **Editor**. If you're not working with an Editor, then you should definitely give it to someone you trust to read through it and give you his or her notes. Even if they only spot typos and punctuation mistakes, it will improve your script immensely.

Please remember the job of the Writer is to *create the best story possible*. Not just so you can say, "I'm a Writer." It takes work to be a real Writer. Do your best. Get help if you need it, and when you turn that script over to the illustrators, you know you've made your best effort.

Sample Script

BLACKJACK COMIC STRIP: "Heart of Evil"

Monday

PANEL ONE

Caption: New York. 1935

Action: (Ext. Night. Go for film noir mood) Wide shot of the front of Arron's Upper West Side house. We see a stylish four-door sedan (circa 1930s) parked in front (left side of the panel). A man stands at the opened front door. The man is dressed in a long coat, a fedora. (We may or may not see that he carries a briefcase. Depends on space.) He is speaking to someone just inside the doorway, though we cannot see that person.

Phillip: I am Phillip Wainwright. I'm looking for Mr. Arron Day.

PANEL TWO

Action: (Int. The house) Arron **Day** stands to the right of the panel. He wears an expensive looking dressing gown (satin lapels, etc.). He is facing the visitor at the front door. To the extreme right, is the open front door. **Wainwright** stands just inside the doorway, facing Arron. Between the two men stands **Tim Cheng Su**. He wears traditional-looking Chinese attire, and sports an expression of annoyance. Tim Cheng is holding the door open; his left shoulder is just behind the door.

Arron: You've found me.

Phillip: I am here to offer you tickets to Paris, ten thousand dollars, and —

PANEL THREE

Action: (Int. The foyer. Same angle?) Two men are bursting in through the doorway. Attacker 1 has already slammed into a shocked Wainwright, knocking him toward the floor. Attacker 2 (behind the first), has slammed the door into Tim Cheng, knocking him back against the wall. Attacker 1 is big (a weight-lifting brute) and has a large hunting knife. We do not see the second attacker's weapon. Arron is leaning back; obviously surprised by the attack, but there is a slight suggestion of a crouch, or stance in the making.

Now it's up to the Penciler, the Inker, and the Colorist to make it even better as a visual experience.

Layouts & Thumbnail Sketching

We've been having a **ton of fun** learning job titles, terminology, and creating a character and character bios.

*Well, **I've** been having fun.*

Still, this is darn useful stuff, and it's even more fun if you've been doing some of the exercises. So, onward...

I know you're probably asking, *"Why did you mention **Thumbnail Sketching** second in the title when it should come first?"*

Some of you are asking, "What the heck is *thumbnail sketching?*"

If you are asking that last question, then you know of why I did it.

See, while writing a comic book or comic strip, the author should envision the tale. That means imagining what each scene looks like.

Thumbnail Sketching simply means you do **light pencil drawings** to suggest the idea of what visuals you want on each page. True, the script will tell you what action **needs** to take place, but the PENCILER has to visualize that and come up with the most interesting or dynamic illustrations.

Many writers see the story like a movie, with *opening shots, lighting, atmosphere, and action sequences*. The tricky part is — we're **not** making a movie. The action and dialogue do not simply flow out in a seemingly endless stream of movement and sound.

We have to *layout*, or design, exactly how many panels and pages each moment will take. We have to consider pacing, too that is,

how to build suspense, tension, drama, and climax. You don't want your readers to feel the story is lagging, aka moving too slowly.

We also think in terms of the *size of an illustration* to generate maximum effect. That includes ...

- Splash Pages (*see below*)

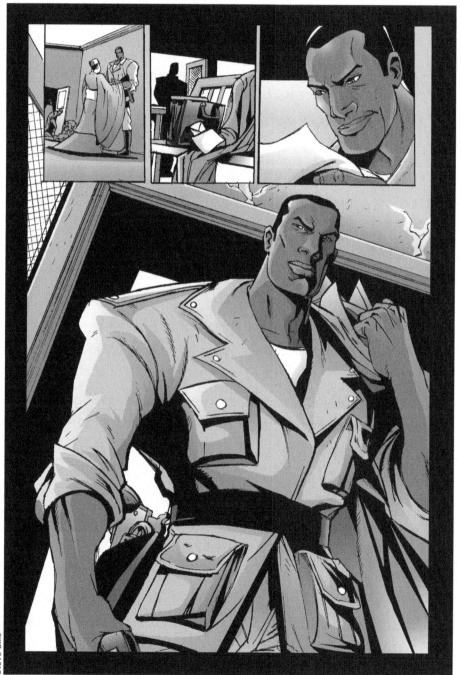

Steve Ellis

- Double-Page Spreads, and
- Page-Turning Cliffhangers

What's a **Cliffhanger**? We'll talk about that later. (*See glossary.*)

The writer has to have a vision of how the story looks. In other words:

Oh, thanks a lot!

Alex Simmons

1. What images must go into each panel.

2. How many panels do we need on each page and what size should they be.

3. What is a good cliff-hanging image to put in the last panel on the right side of the page (unless you're reading manga — then it's the last panel on the left side of the page).

Planning the look of a page helps you affect many aspects of the story.

When the Penciler gets the script, they follow your basic script layout and create a thumbnail sketch to help them plan the visual details.

They consider ...

- Camera angles
- Shapes and sizes of panels
- Position of characters
- Background elements (landscapes, crowds, etc.)
- Spaces for Speech Balloons, Caption Boxes, and/or Thought Bubbles

True, the Penciler is following the writer's plan, but there are still visual elements to work out....

- Spacing
- Visual impact
- Suspense
- Revelation (reveal)
- Dramatic effect
- Settings or locations
- Conveying personalities and emotions
- The proper placement of any visuals clues

That's a lot!

So the Penciler sketches (or *doodles*, if you will) to get a loose idea of how the art on the pages should be positioned. They do all of this before they put in an ***incredible*** amount of time and effort to generate a solid page of finished art per day.

Thumbnail Sketching a rough layout saves the artist a certain amount of time and frustration. And it limits the number of mistakes the artist *might* make when drawing the final *pencil* art.

No one wants to draw a full page of detailed comic art and then realize it doesn't serve the purpose.

At least...no one I know.

The same goes for Comic Strips.

True, there are fewer panels to draw, but it's still a lot work that requires planning.

On the average most comic strips are usually three or four panels, reading from left to right. Sometimes it's a single panel. All this depends on the writer and illustrator's interpretation of the story or joke.

Alex Simmons

For instance if you're laying out a joke in three or four panels, you need to decide what goes in the first panel, and what goes in the last panel. The last panel is obviously your punch line and reaction.

Then you determine what you need to show in the middle.

It's a bit more work if you're telling a continuing story. Then you need to decide a few key things:

- How to divide up the story into separate strips?
- How many strips will it take to tell the whole story?
- What type of cliffhanger to use in the last panel of each strip?
- What will go in the following strip?

Laying out a comic book page is little more complicated.

On the average, you have to determine how to lay out the story using five or more panels per page. You also have to decide what goes in the last panel on each page so that the reader is

compelled to turn the page for the next phase of the story. Meaning you want your illustration to be **compelling**.

So the best method is to work it out **loosely *first***.

Plan it well. Do not do a lot of details in your sketches.

Keep your sketches simple, so ***you can change them easily*** or discard them altogether.

This way you plan out each illustration, and when you do the final pencil art you save time.

You can discover problems in your ideas through your sketches so you won't make them in the final art.

Penciling

Let me start off by saying I am not a professional illustrator. I am nowhere in the league of the artists I admire most, from **Joe Kubert** to **Jamal Igle**. And believe me, the list is strong and long.

Nevertheless, I have studied illustration and practiced it over the years. I also have known and worked with some of the best, and they've taught me theories and techniques. And that's what I plan to share with you now.

So here we'll talk about tools you can use, and some of the visual bulls-eyes you should aim for.

TOOLS

- **Pencils:** (#2) or Mechanical pencils
- **Erasers:** pink wedgie or kneaded
- **Print paper:** (8 1/2 x 11 or 11 x17 in.), or cardstock
- **Blue lined paper**, or **Bristol board** with the blue edges
- **Strathmore 500 plate surface** (the unlined comic book sized paper)
- **Deleter manga manuscript paper** (inexpensive — unlined version around $10-15 for 40 sheets) and durable
- Improvised drawing board (11x17)

Let's start off with the simple fact that as a Penciler you are charged with the responsibility of bringing the visual aspect of your story to life.

Drawing talent differs, style differs, and subject choice and medium differ. But everyone should be focused on creating the best possible visual storytelling experience.

To me this means ...

- Play to your strengths,
- Learn from your mistakes and correct them,

And in the end, run it by an editor or two.

Okay, yes we're working with a pencil, and most of those suckers have erasers. If not, you can buy an eraser — either the pink wedgie ones, which are fine to some degree, or a **Kneaded eraser**. They are soft like clay and can be shaped easily to erase marks in narrow areas of your drawing without accidentally removing artwork you wish to keep.

Of course you can use mechanical pencils. The key thought here is to make sure you use the right kind of lead in your pencils. You do not want one that is too soft. The lines will smear easily — either when you accidentally rub your hands across them, or when you transport the pages. A #2 pencil has a nice, hard lead without being too difficult.

Now To the Script

The writer has described in the script exactly what their vision is for each page. This is not necessarily written in stone. Usually there is room for you to come up with suggestions. Even if you are the writer/illustrator of the story putting details in the script gives you another opportunity to plan things out for maximum effect. It also helps you discover and potential storytelling problems.

Start by ...

Reading the script and getting a clear idea of what the story is about and where it takes place,

- What characters are in it?
- What do they look like?
- What do they wear?
- Time of day
- Atmosphere or mood

As I said before, you are responsible for the visual dynamics in the story. This means you need to choose the angles from which we see the characters and the action.

For example:

If the script calls for a Page **One** scene of three characters talking, that can be an extremely dull sequence if you don't set it up properly. You could do this by choosing...

An **Establishment Shot**, which would show us where all three characters are in the scene, and a little bit of the background.

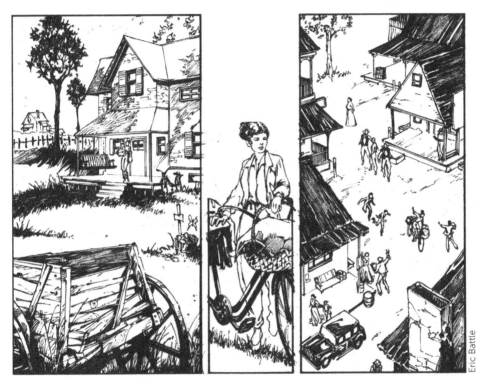

Eric Battle

A **Close-Up**, (*below*) which would focus on only one character at a time. We might only see his or her face, and part of the neck or shoulders, but we are definitely focused on them.

Eric Battle

Eric Battle

An **Extreme Close-up** (*above*), might show the eyes or the mouth and whether or not the character is if it's smiling, sad. The expression might give us some sort of evil, creepy feeling, suggesting the character is dangerous.

A **Two-Shot** (*below*), which obviously focuses on two of the three characters in our particular scene. Perhaps they are speaking to one another or reacting to the third character's comments.

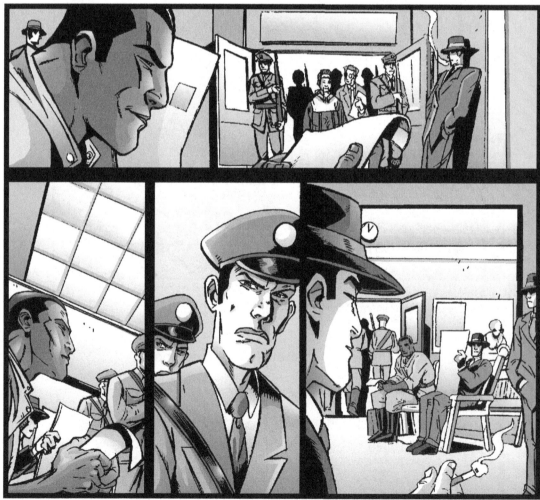
Steve Ellis

A **Medium shot** might have us looking at one or more characters only from the head to the shoulders or head to the chest. Or if you're playing cards and it's important to see their hands, how much money is on the table, and the cards, we would use a medium shot showing a set of hands and probably what is in the pot.

Bird's-eye view. (*at right*) We are above the characters looking down from above.

Eric Battle

Jamal Igle

Worm's-eye view (*above*). Obviously we are now lower or on the ground or down around the knees looking up at the characters or the action that is taking place.

It is up to you to determine which is the best angle for us to watch the action in the scene, and at what time we need to go closer or pull back from the action. Being

flexible with your camerawork keeps the visuals interesting, much like watching a TV show or a movie. But don't do tricky camera angles just for the sake of doing a camera angle. Try to use each trick in a way that supports or makes the story more engaging, drawing our attention to it, building suspense, and so on.

So what kind of pencils are we using?

Like painting and other visual forms, many artists differ in the type of tools they like to work with. For our purposes I would suggest your basic #2 pencil — it's not too soft, so it doesn't easily smear ... and that's definitely one thing you do not want with your pencil art. You don't want the lead smearing too easily as you work on the art, or if you should happen to rest your arm on something you've drawn. Also, really soft lead not only will smear when you're working on it, but in transporting your work. Imagine laying the pages on top of each other, putting them in an envelope, going to deliver them to the printer or whatever — and discovering that just the action of rubbing together had smeared your pencils!.

A #2 pencil is a solid tool. For those who'd like to use mechanical pencils, again I suggest a medium or hard lead, but not soft lead — more on that further in the book.

As for erasers, obviously your basic #2 pencil comes with a little pink one on the non-pointy end. You can also buy the larger pink erasers; they're good for working on bigger projects. But as I said before, I highly recommend a **Kneaded Eraser** for several reasons. Not only is it easy to manipulate, so you can get into the small spaces in your drawings, but it's also not as abrasive to the paper you're working on. It doesn't tear up the paper fibers as easily when you erase something, so your page stays relatively smooth and clean, and your pencil strokes don't look different.

Standard comics tend to go with four to five panels per page, at least in western civilization (or in the United States), but

European comics and graphic novels sometimes fit as many as twelve and fifteen panels on a page. And certainly in our new era of independent comics the artist could choose many different ways to lay out a page and how many panels to use. I recommend that you focus on pacing your story first — be clear on what takes place on each page, and whether or not you need a few panels or lot of them to create the proper sense of motion. Of course, most of this you have worked out in your thumbnail sketches and your layout (didn't you?), so your pencil work is really the detail job. Now you just have to draw your pants off.

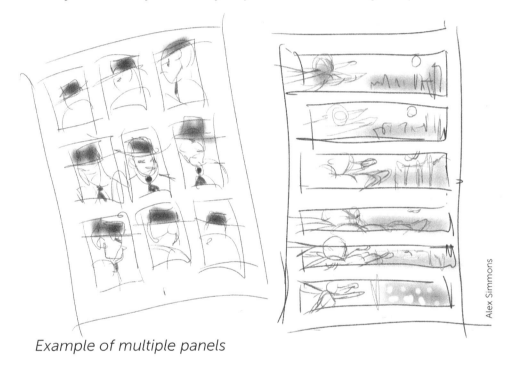

Alex Simmons

Example of multiple panels

Make sure your figures are solid, meaning they look properly proportioned. Or if your style is less realistic, with different body proportions or poses, make sure that the line work is pleasing to the eye. If a character is in action, make it look as though they're in motion. If they are standing still, make sure they're standing on the ground and not floating above the horizon line. You want your line work to be clean and crisp. And remember to leave room for your speech balloons, caption boxes, or thought bubbles. You do not want to get stuck lettering over an important part of the art.

Dynamic Panel SFX & Page Turners.

Much like doing a comic strip, you want to motivate your readers to keep going through the story, to be so caught up in what's happening they can't wait to see what's on the next page. Remember when I mentioned putting a cliffhanger in the lower right-hand corner of each page? Again, the idea is to be compelling.

Whatever you choose to lay into that panel, make sure it makes your audience want to turn to the next scene or the next page.

Once you've finished your pencils, step away from them for a day or two. Go back and:

- Check for mistakes
- Check for accuracy
- Check for proportion.

If there are areas that need to be filled with solid black, indicate that by inserting small X-marks in those spaces. *(see example on opposite page).* This will tell your Inker what he or she should do with that particular area. Please remember your Inker is coming up behind you to embellish your work, to make it looks its best.

If you're thinking the job and you're good at anything keep in mind that once again your job is to make your pencils more striking bold clean dynamic so once again do your best pencil work so that your clear What your next move will be with your inking pen or brush.

Again mentioning old school methods vs. new technology, if you are going old school with your project then you have penciled your artwork you will then go and do your lettering and then you're thinking.

If you're working on computer either part way or fully you have the option of doing your pencils first, scanning and doing your inking on computer. Or doing your pencil, inking and scanning

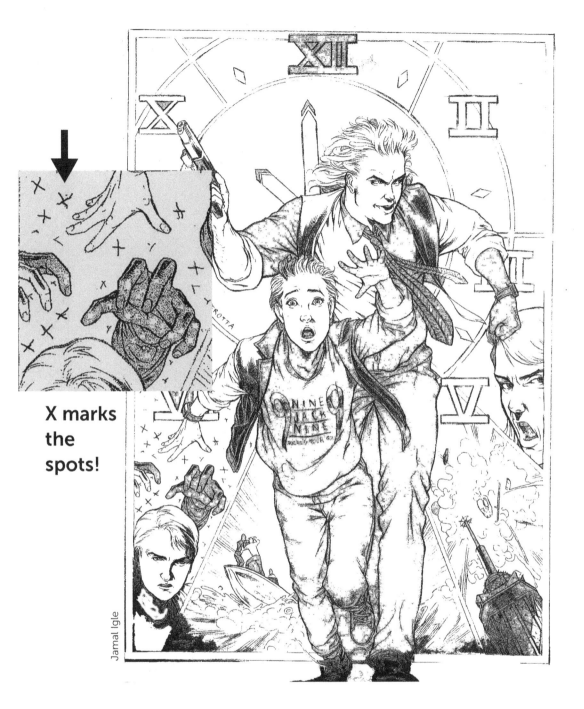

X marks the spots!

Jamal Igle

first. Then send that image file to the letterer. Now the lettering can be done on computer. Obviously your coloring can be done on computer too (*see chapter on Coloring*)

As I said I am not what I would call a professional illustrator I'm a bit of a cartoonist and I have illustration skills to some degree

but I am quite clear about the Caliber of work that I appreciate and when I do a project if I don't feel I'm good enough to illustrate that project I turn it over to people who are once again your main goal is to turn out the best possible book you can. So don't be ashamed to look for help, or assistance.

8 Lettering

If you think that comics are all about the art ... you are only two-thirds right. Sure, the visuals are important. Often the very reason someone buys your work is because of the cool or exciting images.

But here's a thought ... just how satisfying would it be if they could not read your story? What if the words were scrawled, illegible, crunched/squeezed/squashed into shapes that clumsily obstructed the illustrations?

- What if the sentences were confusing, or the key words misspelled?

(Examples: *their, there, they're, or see, sea, etc.*)

- What if the special effects words didn't pop?

Like live theater, the show is only as good as the sum of all its parts. So, let's look at the art of lettering. Here are certain basics that you should adhere to...

1 When doing layouts for your art, leave enough room for your lettering

2 Draw guidelines for your lettering, so the words are straight, unless you're going for a certain affect.

Student art

3 Write out your words before drawing your speech balloon, thought bubble, or caption box shapes. This guarantees you will be able to fit everything in properly, eliminating squeezing and squashing of words.

4 Ink nothing until you've checked for mistakes (misspellings, omissions, etc.)

Getting Fancy

You have three basic ways to do lettering these days:
- Hand lettering
- Lettering on computer using standard fonts
- Lettering on computer using commercial fonts obtained from websites such as Comixcraft fonts, dafont.com and Blambot. (*these vary in price from free to low cost donations to the font creators*).

Some might say that hand lettering is too old-school. Well yes it is, but that is not a bad thing. Lettering by hand is an art skill by itself. You need to keep your hand steady, and it requires patience and in some cases a certain amount of graphic creativity, but it allows you to create different lettering styles *by hand*.

To be real...some young artists don't have the coin to purchase some of the comic lettering fonts. So hand lettering is a definite avenue to keep the project going.

Font examples...

ART OF MAKING COMICS

ART OF MAKING COMICS

ART OF MAKING COMICS

ART OF MAKING COMICS

ART OF MAKING COMICS

Free or paid, many of these offer you different font styles, in different languages (*cultural styling*), and special effects.

Whatever you decide, creating a quality experience should be your first goal. Fancy doesn't make it better. Clear and legible storytelling **does**.

Inking 101

Ah, the joys of inking.

Some might think inking is the easy gig. After all, you're only going over the lines that the Penciler has already drawn. The Penciler has figured everything out, so you don't have to, right?

Wrong.

The Penciler may have created the illustrations, but now the Inker has to go over every single line and not make a mistake.

Now, professional INKING is not my ball game. I can do it well enough to fit some of my *own* art projects, but I would never seek a job as an INKER.

This is a sign of great wisdom on my part.

When producing your comic book or comic strip, it is better and more beneficial if you **admit what you don't know**. This opens you to learning how to do it right, or to bring in someone good to do it for you.

Why?

Because your goal should always be to do the job right! You want it to be the best it can possibly be.

So if you are not so good at something, own up,]so your project doesn't suffer.

Okay, so if I'm not an Inker, what do I know about anything? I know what it takes, and I know how it's done. And that's what I'm going to share with you now.

An Inker is not a photocopier. The Inker doesn't just simply trace the pencil artwork.

An Inker's job is to **embellish** the art, that means to make it look its best, or even better. It's sort of like the job makeup artists

do for actors before they go out and perform. They make them look their best for the cameras, spotlights, or stage.

The Inker makes the light pencil lines darker, crisp, bold, and more dynamic. This creates a better dramatic effect and clear printing, especially in black and white.

It also simplifies the coloring process if you do it on a computer. (*More on that in another chapter.*)

Now to the inking process itself. Let's look at the "old-school" method first.

Jamal Igle

Once you've finished and double-checked your pencil art and the lettering, go through the art again to indicate what areas should be in solid black.

You can choose these areas by making several small X marks in those spaces. Another thing you can look for is align wait (*More on that later.*)

Choose your inking tools carefully. (*see the list on top of p. 57*)

Unless you are very comfortable using a brush, I suggest you use inking pens. The Micron line offers good ink and a variety of line sizes, at a price that won't break the bank. But there are several different brands on the market. So buy a few and test them on sample art to find out what works best for you.

Okay, once you've found a brand of pen that works for you, select the point size based on the thickness of the line you want to use. Line thickness can be different for characters' faces and hands versus clothing or machinery.

Some artist like to draw thick outer lines around their characters and then use thinner lines for the art inside that outline (*faces, hands, clothing, etc.*).

58

INKING TOOLS

OLD-SCHOOL

- Various types of sharpies and inking pens
- **Sakura Microns** and comic multilines for fine details.
- **Windsor Newton Series 7** brush
- Japanese brush pens: **Sailor, Pentel, Kuretake**, and **Managua Flex** (jetpens.com has a wide selection)

DIGITAL

- **Clip Studio Pro** (aka Manga Studio)
- **Frenden Brushes** for Photoshop and Clip Studio Pro

To start …

- Carefully draw the point of the pen along the pencil lines.
- **Take your time**.
- Do not be afraid to stop and rest your hand, or change angles for easier access and comfort.

As with thumbnail sketching or writing outlines for your scripts, it's better to plan your moves ahead of time.

Work from right side to left if you are **left-handed**. This will help prevent you from dragging your hand over any wet ink, smearing the art or leaving telltale smudges.

Here are a few ways to avoid making mistakes on your final pencil art.

OPTION ONE:

- Place tracing paper over the pencil art and test your inking skills on that.
- If you make a mistake, simply remove the tracing paper and start over. Your original pencil art is always protected.

- If you like what you've done, you can always photocopy it and then scan it into the computer. (*More on that later.*)

OPTION TWO:

- Make sure your pencil art is clean of false lines and smudges. (Use a soft eraser.)
- Then scan it at 300 to 600 DPI into your computer.
- Save it as a JPEG or Tiff file.
- Next, open the file in Adobe Photoshop (*or another comic art or art manipulation software*).
- Using the **wand tool,** click on the black lines that you want to darken.
- Once they are "captured" (indicated by the "marching ants" effect), take the **bucket tool** and touch it to the captured area.
- The bucket tool will pour digital black ink into the highlighted areas only.
- Do this everywhere you want a line or area to be solid black.

Jamal Igle

For some, this is a more complicated method of inking. For others, it saves time and some frustrations.

Addendum: check all art, spacing, sizes, and spelling before you ink your work.

10 Coloring

There are two methods for coloring your comics.

Coloring Your Comics the OLD-SCHOOL Way

Once again I will start out with a little piece of advice ...

NEVER COLOR YOUR ORIGINAL!

First, make a clean, B&W copy of your art. Then, using color markers, color pencils, or watercolors, experiment with coloring your work. Repeat these two steps until you have a coloring job that you like. Keep the one that looks the best, and use that as your finished art. Or you can make that your COLOR GUIDE (more on that later.)

Now ...

- Scan the colored art at 300 dpi for best resolution and reproduction quality.

- Save the scanned file as a JPEG or TIFF file.

- Open the file in Adobe Photoshop, Manga Studio, etc.

- To avoid any possible disasters, **SAVE YOUR WORK** every few steps. Do not wait until you have finished everything.

- Save the file at the highest resolution (10 or 12 megapixels). Then print it out, send it to a printer, or upload it to the web.

(An example of flat color rendering on the right)

Jamal Igle

Coloring Your Comics on the Computer

Start by using color markers, color pencils, or water colors to experiment with coloring your work on a black-and-white photocopy. You can choose to keep the colored version that looks the best, and use that as your finished art. Or you can make that your COLOR GUIDE and ...

- Scan the best black-and-white copy of your finished comic project. Scan it at 600 dpi for best resolution/quality.

- Save the scanned file as a JPEG or TIFF file.

- Open the file in a program called Adobe **PHOTOSHOP**.

- Using your color guide, color in your work using the trusty bucket fill and the millions of colors available from Photoshop. Depending on how good you are with the program, you can add some special effects or graphics.

- To protect your work-in-progress, SAVE YOUR WORK every few steps. Do not wait until you have finished everything. (If this sounds familiar, you read it on the last page. But it's better to remember it here than to remember it after you've destroyed hours of work with a mistake you can't recover.)

- And at the risk of repeating myself, save the file at the highest resolution (10 or 12 megapixels).

Then print it out and away you go!!!

Jamal Igle

11 Publishing

Hard Copy or World-Wide Baby?

So now you've got your words and your art together in one great package.

There are three different ways you can do this in today's amazing Marketplace.

1. If your project has a black-and-white interior, you can complete your comic book and take it to a printer or a copy center (FedEx, Staples, etc.). You can print on 8 ½ x 11 paper, add an attractive cover, create as many copies as you want, and sell them to your friends, family members, and fans. That's the old-school way — it's still quite viable for a number of people breaking into the marketplace and trying to save some dollars. Doing a book in color is more expensive, of course.

2. You can prepare a digital file and send it to one of the print-on-demand companies, ala Ka-Blam or CreateSpace, to name a few. This allows you to create a more professional-looking comic book, meaning it will be printed on good paper, in black and white or color, and it will be the same size as a standard comic book. The two standard sizes are 6.75" x 10.5" or 7" x 10.5", full bleed. The quality of the book is on you. Also, when using CreateSpace not only can you print books to sell at live venues, you can also have your files prepped to sell as digital downloads on your website, Amazon, iTunes, and such. This offers you more exposure beyond the places you can go to yourself.

3. Piggy-backing on Method 2, you can forget printing books altogether. Instead, you can create a comic book that is **only** available online. This means you can save your work as a

digital file, or a PDF, on your website or a special landing page you set up. Then offer it as a digital product that people can look at on their handheld devices or their laptops. As a digital file you also have the advantage of being able to do the entire book in full color, because it won't cost you extra to print it. If you make the book available on your website as a webcomic, you can build an audience for your stories or your series, and it won't cost you anything for shipping, either. Some people make their books available for free to get more exposure and build a fan base. Then they create books to sell. The choice is up to you ... period

Whichever method you choose, it's best make that decision after thinking about your resources. Such as:

1 How much money do you have to spend on the project?

2 Do you intend on going to conventions and other venues that will allow you to sell a handheld version of your book?

3 Will you go to conventions and other events to hand out samples of your book in hopes of getting work from other companies?

Another thing you should consider is ...

Are you doing this project to **make money** *or to* **build a name** for yourself so you can be hired to do work for others?

These are things you should devote a lot of thought to as you decide which method you plan to use to publish your book.

There are few other steps you have to consider if you're actually going to become a comic book publisher.

1 How will you distribute the book?

2 How will you promote the book?

3 How will you generate income to make it possible to continue printing the book or continue creating the next issue in the series?

If you are the writer-creator and illustrator for your series, then you're in good shape, because you don't have to pay

anyone else. But if you are one part of a team producing the project, then you have to determine whether you can persuade someone to illustrate or write the book (depending on which skill you need). Will they do this for free, or will they do the job for what is called a back-end deal, meaning they get paid out of whatever money you make from selling the book. You also have to set up a schedule for getting the book done, for getting the book out, for getting the book to the various sources or venues that will sell it or otherwise reach your fan base. Believe me, whether you do it online or by hand, distribution is a big factor.

So becoming a publisher is not simply saying, "Wow, I created a book, let me fling it out there." There's a lot to think about if you want to do it correctly. I would suggest very strongly that you talk to people who have done this, as many as possible before attempting to do it yourself. Go to conventions and talk to other independent comic book promoters, talk to people who work for some of the bigger companies. Then look at your resources, look at your personal time, and determine which is the best route for you.

That's all I have to say — except "**Good luck!**"

Create Your Own Publishing
Plan Here

12 Diverse Population of Characters

Here's one more personal note from yours truly.

The world is an amazing place, filled with a variety of wondrous people, places, and things.

Sometimes artists miss that.

This can be due to the fact that the creator (writer or artist) has no direct knowledge or experience with people or things that are different from themselves. Sometimes it is a matter of politics or personal philosophy.

I believe that as artists we are given the gift of reflecting the world through our art. The comic art form is not a narrow one with only a few possibilities. Many people of different origins or predilections have created important comic art and not sold their souls in the process.

As writers we accept the torch of chronicling the world's stories, so they are never forgotten.

As a person of color (African-American) I tap into that part of my life to find connections with history, goals, discoveries, etc. I don't ignore the Anglo-Saxon world, but I also embrace the myriad hues of the rainbow that is the human race.

You can do that, too.

The fun thing about being a storyteller is that you can explore the world you know, as well as the one you choose to discover.

We can also tell funny or sad stories about the life around us. We can make people laugh, feel super-powerful, proud, or amazed.

You can do so much if you just observe the world and build on what you see.

So now with the skills you've learned and the ones you were born with, go forth, have fun, and be brilliant.

Sincerely,
Alex Simmons

Panels: The shapes on the page containing the artwork (i.e. square, rectangular, circular, etc.)

Caption Boxes: Shapes often inside the panels that contain narration or text.

Speech Balloons: Shapes that contains the words spoken by the characters.

Thought Bubbles: Shapes (often cloud, oval, or smoke-like) that contain the character's thoughts.

Characters: The beings within the story (humans, animals, ghosts, robots, etc.) that have been given some form of life and personality.

Cliffhanger: An episodic film or story containing a suspenseful situation that happens near the end of a chapter or scene.

Outlines: A form of written list that shows in sequential order the proposed story journey from beginning to end.

Script: The written story in proper comics, screen, or stage format.

Narration: informative statements that guide the reader through the story.

Splash Page: Contains a single illustration that takes up the entire page.

Double-page Spread: Can contain a single illustration that spreads across two side by side pages.

Gutters: The deliberately formed margins between panels.

Thumbnail Sketches: Often a series of light, rough sketches that suggest how the artist might want to layout the pages, or design characters.

Character Sketches: A series of drawing that clearly show what a character looks like (front, back, & sides), as well as what they wear.

Character Biographies (Bios): A detailed list of information about a character and it's relationship to others in the story.

Graphics: Graphics are usually the images, logos, and text found in books and other media.

Graphic Designer: Except for the story illustrations, this is the person who often designs the logo, chooses the fonts and color scheme, as as images (sometimes), and composes the visually pleasing order in which they are displayed.

Thanks

Edited by

WILLIAM McCAY

Additional art furnished by

SHAWN ATKINSON

ERIC BATTLE

STEVE ELLIS

TIM FIELDER

JAMAL IGLE

ALEX SIMMONS

Design & Art Direction by

ELIZABETH SHEEHAN
elizabethsheehandesign.com

Made in the USA
Las Vegas, NV
04 March 2022